Written by **Luke Barnes**
Presented by **Scrawl**
Bush Theatre, Radar 2012

Chapel Street is presented by Scrawl in collaboration with Richard Jordan Productions at the Bush Theatre as part of RADAR 2012: Signals from the New Writing World, with the following cast and company:

CAST
JOE: Theo Barklem-Biggs
KIRSTY: Ria Zmitrowicz

CREATIVE TEAM
Writer: Luke Barnes
Director: Cheryl Gallacher
Creative Producer: Laura Elliot
Lighting Designer: Lee Curran
Collaborative Producer: Richard Jordan Productions

Chapel Street was first produced by Scrawl for the Edinburgh Festival as part of Old Vic New Voices Edinburgh Season 2012 in partnership with the Underbelly and supported by Ideastap, with the following cast and company:

CAST
JOE: Cary Crankson
KIRSTY: Ria Zmitrowicz

CREATIVE TEAM
Writer: Luke Barnes
Director: Cheryl Gallacher
Creative Producer: Laura Elliot
Assistant Producer: Jordan Eaton
Casting Director: Sophie Davies
Designer: Holly Seager
Lighting Designer: Lee Curran
Old Vic New Voices Mentors: Steve Winter, Michael Longhurst and Joanna Mackie

Chapel Street was also kindly supported by
The Oxford School of Drama, New Initiatives Fund.

Special Thanks

Thank you to all the people and organisations that gave us money, space, time, advice, funding and creative support:

Paul Zmitrowicz, Susan Barnes, Teri Church, Matthew Burrows, Jacqui Elliot, Brian Elliot, Sian Elliot, Heather Elliot, Margaret Gilbert, Terry Gilbert, Ron Elliot, Gill Bannon, Lina Irmaln, Susan Burrows, Joanna Mackie, Steve Winter, Amanda White, Micheal Longhurst, Peter de Haan, Sophie Davies, Kady Howey Nunn, Holly Seager, Dan Kendrick, Cary Crankson, Jordan Eaton, Nathania Wong, the Royal Court Theatre, the Young Vic Theatre, the Lyric Hammersmith, London Bubble, artsdepot, Kerry Andrews, Nina Green, Lee Curran, Andy Divers, Graham Weymouth, the Old Red Lion Theatre, the Bush Theatre, Old Vic New Voices, the Underbelly, the Liverpool Everyman Playhouse, Oval House Theatre, Alex Austin, Theatre503, The Hospital Club, Leslie Cuthbert, Alex Rand, Vinay Patel, Peter Forrest, Matthew Hull, Jakie MacPherson, Amanda Hewitt, Imogen Rose, Chris Pickering, Rachel Jackson, Gavin Jones, David Jacques, Alex Burke, Sophie Guarella, Amelia Griggs, Geoffrey Griggs, Ashley Eaton, Margret Flanagan, Truc Bishani, John Bentley, Virginie Pithon, Jon Barton, Peter Forrest, Mai Cunningham, Catriona Early, Angela Sujadi, Cat Robey, Alex Brenner, Orion Lee, Steph Lyonette, Toby Clarke, Theresa Wong, James Wong, Rose Loh, Nina Ngiam, Joanne Loh, Florence Loh, Sara Debevec, Rae Early, Lucrezia Botti, Abul Aziz Ahmad, Dominic Mullings, Jennifer Choi, Joseph Hodges, Carly Haise, Tara Bosworth, James Graham, Rachel Delahay, Tom Wells, Kenny Emson, Richard Jordan, David Mumeni, Seda Yildiz.

And thank you to organisations that gave us funding:
The Oxford School of Drama New Initatives Fund, IdeasTap, The Peter De Haan Charitable Foundations, Underbelly and Old Vic New Voices

CAST

THEO BARKLEM-BIGGS Chapel Street is Theo's theatre debut. Film credits include *Hammer of the Gods* (Vertigo, dir. Farren Blackburn), *Survivors* (dir. Farren Blackburn) *Keith Lemon – The Movie* (Lionsgate, dir. Paul Angunawela), *The Man Inside* (Scanner Rhodes, dir. Dan Turner), *Borrowed Time* (Film London / Parkville, dir. Jules Bishop), *The Inbetweeners Movie* (Young Bwark, dir. Ben Palmer), *7 Lives* (Starfish Films, dir. Paul Willkins), *Age of Heroes* (Giant Films, dir. Adrian Vittoria), *Jewfro* (Short Film, dir. Alex Norris), *What If...* (BBC / Film 4 (short), dir. Max & Dania), *Compulsion* (Short Film, dir. Andrew McVicar). Television credits include *Silk* (series regular, BBC1), *A Touch of Cloth* (Zeppotron / Sky, dir. Jim O'Hanlon), *The Fades* (BBC3, dir. Farren Blackburn), *Miranda* (BBC1, dir. Juliet May), *Silent Witness* (BBC1, dir. Keith Boak), *Holby City* (BBC1, dir. Dominic Keavey), *Coming Up* 'Dip' (Touchpaper / C4, dir. Lisa Gornick), *Law and Order* (Kudos/BBC1, dir. James Strong), *New Tricks* (Wall to Wall / BBC1, dir. Robin Sheppard), *Dogs Bite* (Kindle Entertainment, dir. Mark Munden), *Micromen* (Darlow Smithson, dir. Saul Metstein), *How Not To Live Your Life* (Brown Eyed Boy / BBC3, dir. Martin Dennis), *Moses Jones* (BBC1, dir. Michael Offer).

RIA ZMITROWICZ Ria trained with the National Youth Theatre. Her theatre credits include *Chapel Street*, which won the Emerging Talent Award in Edinburgh earlier this year, *Skanky* (Arcola), *The Grandfathers* (Oval House), *The Site* (Camden Roundhouse), and *Routes* (Hampstead Theatre.) Television credits include *Whitechapel* and *Youngers* (a new series for E4). She will soon been seen in *Murder On The Homefront* on ITV1.

CREATIVE TEAM

LUKE BARNES, WRITER

Chapel Street is Luke's first play, first presented as an earlier version at the Old Red Lion Theatre in London and then at the Liverpool Everyman Playhouse as part of the Everyword season. It received its first full production, produced by Scrawl as part of the Old Vic New Voices' Edinburgh Season 2012 in partnership with the Underbelly, supported by IdeasTap before transferring to the Bush Theatre as part of RADAR 2012. Luke's other work includes: *Bottleneck* (Soho Theatre produced by HighTide Festival Theatre), *Weekday Nights* (Unicorn Theatre produced by The National Youth Theatre of Great Britain) and *Eisteddfod* (Latitude Festival produced by HighTide Festival Theatre). He was runner-up in 2012 for Most Promising Playwright at the Off West End Awards and is currently Leverhulme Playwright on Attachment to the Liverpool Everyman Playhouse Theatres.

CHERYL GALLACHER, DIRECTOR

Cheryl directed Luke's first play for the Old Red Lion Theatre, London and the Liverpool Everyman and Playhouse in 2011. She went on to develop the full production of *Chapel Street* for Scrawl as part of the Old Vic New Voices' Edinburgh Season 2012 in partnership with the Underbelly, supported by Ideastap. Cheryl devises, scripts and directs for TheatreState. As Co-Head of State, Cheryl is currently working on *The Fanny Hill Project* development at the West Yorkshire Playhouse. Cheryl is also Programme Director of Southwark Theatres' Education Partnership (STEP) and as Assistant Director, her credits include *Desire Under the Elms*, directed by Sean Holmes at the Lyric Hammersmith. Training includes the Directors

Course at the National Theatre Studio (2012) and the Young Vic Springboard Project for Emerging Directors (2011).

LAURA ELLIOT, CREATIVE PRODUCER

Laura is the Founder and Executive Producer of Scrawl and first produced *Chapel Street* at the Edinburgh Fringe Festival as part of the Old Vic New Voices' Edinburgh Season 2012 in partnership with the Underbelly, supported by IdeasTap, before transferring the production to the Bush Theatre as part of RADAR 2012. Alongside running Scrawl, Laura is the Programme Manager for Warwick Arts Centre. Prior to this she worked as a programmer and producer for artsdepot, in the Development Team at the National Theatre, and a Marketing Assistant for Jo Hutchison international with Hightide Theatre.

LEE CURRAN, LIGHTING DESIGN

Theatre includes: *Constellations* (Royal Court & West End), *The Sacred Flame* (ETT), *Clytemnestra* (Sherman Cymru), *The Fat Girl Gets a Haircut* (Roundhouse), *Great Expectations* (ETT/Watford Palace), *66 Minutes in Damascus* (LIFT), *The Rover* (Artluxe), *Toujours et Près de Moi* (Opera Erratica) and *Unbroken* (Gate). Dance includes: *Political Mother*, *The Art of Not Looking Back*, *In Your Rooms* and *Uprising* (Hofesh Shechter), *The Perfect Human* (CandoCo), *Curious Conscience* (Rambert), *E2 7SD*, *Voices* and *Set Boundaries* (Rafael Bonachela), *There We Have Been* and *Everything and Nothing* (James Cousins), *Lyrikal Fearta Redux* and *The Letter* (Jonzi D), *Revolver*, *From The Waist Up* and *Sticks and Bones* (Darren Ellis), *The Impending Storm* (IDFB), *Omi* (Tony Adigun), *Have We Met Somewhere Before?* (PROBE), *Singing* (Jonathan Burrows Group)

and works for Dance United. www.leecurran.net @leecurran

RICHARD JORDAN PRODUCTIONS LTD, COLLABORATIVE PRODUCER

Richard Jordan Productions Ltd is an award-winning UK and international theatre production company which, since 1998 under the leadership of producer Richard Jordan, has produced over 170 productions in 17 different countries including 49 world premieres. Richard has enjoyed a long relationship with the Bush Theatre where as an Associate Artist his productions included: *Nine Parts of Desire; Monsieur Ibrahim and the Flowers of the Qur'an* and *The Stefan Golaszewski Plays*. Richard has been at the forefront of developing and presenting works by a diverse range of established and emerging writers and artists such as: Alan Ayckbourn; Conor McPherson; Omphile Molusi; Alan Bennett; Cora Bissett; Athol Fugard; David Greig; Martin McDonagh; Ryan Craig; Danai Gurira; Nikkole Salter; the Q Brothers; Heather Raffo; Stefan Golaszewski and Belgian collective Ontroerend Goed. His past productions have won a variety of awards including: The Lucille Lortel Award; The John Gassner Award for Best New American Play; seven Scotsman Fringe First Awards; two Herald Angel Awards; three Helen Hayes Awards; three Obie Awards and The US Black Alliance Award. He has been named six times in *The Stage* Newspaper's Top 100 UK Theatre Professionals and most recently his co-production of *Roadkill* was recipient of the 2012 Laurence Olivier Award for Outstanding Achievement at an Affiliate Theatre. Richard Jordan has been mentoring Scrawl and its founder Laura Elliot following their success in Edinburgh.

CHAPEL STREET

It's Friday and Joe is out on the night of his life. Kirsty has bought some vodka on the way home from school and is hastily shaving her legs with her friend's dad's razor. As bottles are drained and their worlds collide, a tale unfolds which will change their lives forever.

Chapel Street is the debut play from one of the UK's most exciting new writers, Luke Barnes. Crackling with energy and dripping with humour it is a bold, lyrical and deeply intimate portrayal of a disaffected generation, which carries a pertinence in the wake of David Cameron addressing 'Broken Britain'.

'*Chapel Street* was born out of wanting to explore the people in the world I grew up in, the problems they encounter and how they deal with them. It's about their ambitions, their short comings and their secrets all woven into one night of carnage. We hear how they see the world through their vodka hazy retinas and how they are hit with the sober, hungover-fuelled reality of their lives' Luke Barnes, writer

WINNER Old Vic New Voices Edinburgh Award,
Brighton Fringe Emerging Talent Award

MUST SEE!
The Stage

★ ★ ★ ★ 'wittiest most engaging performances this fringe'
The Independent

★ ★ ★ ★ ★ 'Blisteringly funny, audacious, and moving'
Broadway Baby

★ ★ ★ ★ 'fizzes with contemporary vitality, sharp humour'
The List

★ ★ ★ ★ 'never falters short of excellent... It'll leave you staggered and mesmorised'
No Borders Magazine

★ ★ ★ ★ 'the most powerful and unpretentious work seen at the Fringe...politically so refreshing'
Fringe Biscuit

★ ★ ★ ★ 'invigorating…its pertinence and honesty make essential viewing'
Exeunt

About SCRAWL

Scrawl is an award-winning theatre company and producer of new plays, set up in 2012 following support from Old Vic New Voices and Ideastap to champion new writing. We are committed to working with today's most exciting new voices to create bold, immediate and wholly original risk-taking theatre that sparks an intimate relationship between the actor, the text and the audience.

Ran by creative producer Laura Elliot and associates Luke Barnes, Cheryl Gallacher and Ria Zmitrowicz, their first show *Chapel Street* went on to critical acclaim at Edinburgh Fringe Festival 2012.

If you would like to find out more or how you can get involved with us please visit:
Website: www.scrawl-online.com
Twitter: @ScrawlTheatre
Facebook: www.facebook.com/ScrawlTheatre

BUSH THEATRE

About the Bush

The Bush Theatre is a world-famous home for new plays and an internationally renowned champion of playwrights and artists. Since its inception in 1972, the Bush has pursued its singular vision of discovery, risk and entertainment from a distinctive corner of West London. Now located in a recently renovated library building on the Uxbridge Road in the heart of Shepherds Bush, the theatre houses a 144-seat auditorium, rehearsal rooms and a lively café bar.

www.bushtheatre.co.uk

REHEARSAL IMAGES

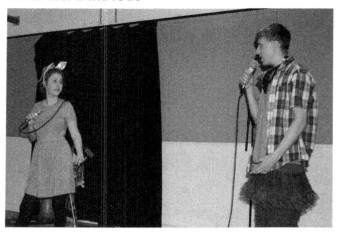

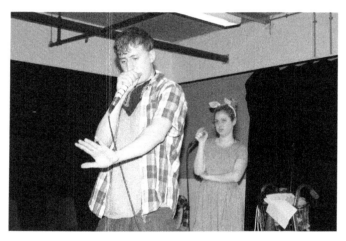

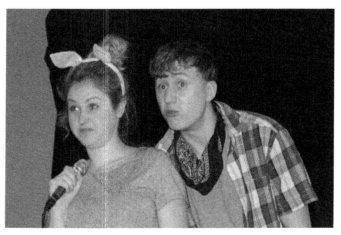

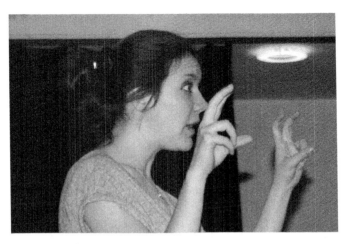

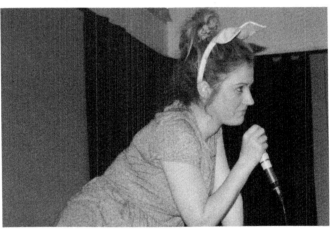

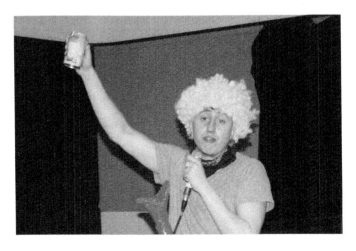

CHAPEL STREET

LUKE BARNES

CHAPEL STREET

OBERON BOOKS
LONDON

WWW.OBERONBOOKS.COM

First published in 2012 by Oberon Books Ltd
521 Caledonian Road, London N7 9RH
Tel: +44 (0) 20 7607 3637 / Fax: +44 (0) 20 7607 3629
e-mail: info@oberonbooks.com
www.oberonbooks.com

Reprinted in 2013

A catalogue record for this book is available from the British Library.

PB ISBN: 978-1-84943-426-3
E ISBN: 978-1-84943-715-8

Cover photography by Alex Brenner

Printed and bound by Marston Book Services Limited, Didcot.

In memory of my Grandmother: Evelyn Barnes
This book is for her and all my family I don't see enough

Characters

JOE
(23) – Unemployed

KIRSTY
(16) – Schoolgirl

NB the language is a representation of dialect.

Chapel Street was first produced by Scrawl for the Edinburgh Festival as part of Old Vic New Voices Edinburgh Season 2012 in partnership with the Underbelly and supported by Ideastap, with the following cast and creative team:

JOE: Cary Crankson
KIRSTY: Ria Zmitrowicz

Writer: Luke Barnes
Director: Cheryl Gallacher
Creative Producer: Laura Elliot
Assistant Producer: Jordan Eaton
Casting Director: Sophie Davies
Designer: Holly Seager
Lighting Designer: Lee Curran
Old Vic New Voices Mentors:
Steve Winter, Michael Longhurst and Joanna Mackie

After a sell-out run in Edinburgh, *Chapel Street* transferred to The Bush Theatre as part of radar 2012, presented by Scrawl in collaboration with richard Jordan Productions with the following cast and creative team:

JOE: Theo Barklem Biggs
KIRSTY: Ria Zmitrowicz

Writer: Luke Barnes
Director: Cheryl Gallacher
Creative Producer: Laura Elliot
Lighting Designer: Lee Curran

An earlier version of *Chapel Street* was presented in 2011 at the Old Red Lion Theatre in Islington and the Everyword Festival at the Liverpool Everyman Playhouse with the following cast and creative team:

JOE: Daniel Kendrick
KIRSTY: Ria Zmitrowicz

Writer: Luke Barnes
Director: Cheryl Gallacher
Producer: Thomas Moore
Casting Director: Sophie Davies
Designer: Kady Howey Nunn

JOE and KIRSTY stand facing front. In separate worlds. Not together. Talking to the audience.

JOE: It was watching me. It wasn't looking at me but I knew it was watching me. I could tell because it was still. They're never still. Don't trust them when they're still. I put my head in *The Sun*. It edged closer. I did one of those little kick things. yano to scare it but I accidently kick it in the face. Feathers everywhere. It flies back at me. So I hit it with *The Sun*. Whack. Twat it over and over again with Sarah, 21 from Liverpool's, tits. I look up and someone little pube from W.H. Smiths is watching me.

KIRSTY: It's really shit. It's really really shit. I mean, I don't know why we keep doing it. It's always the same. Boys in checked shirts. Orange skinny girls.

Fat men grabbing your arse when you go the bar. Sarah loves it. Sad bitch. This is why I have to work. I have to work to get away from this.

Fat men and young girls. I mean I'm proud of where I'm from.

It's just not a good place to get stuck. And I don't want to still be doing this when I get older. They fucking love it. Every weekend they love it.

And to be fair, if it hadn't happened I would still love it, too.

JOE: The pigeon flies away as the train pulls in. The doors open. Woggy's standing there looking like that guy from *The Crystal Maze*. His head all bicced. I take his bag and usher him into the pub. Pint of Strongbow. Alright Baldy. Got to be careful with him. After where he's been and especially what he's come back for, I don't ask him how it was because I don't want to hear about it. So I just straighten out my paper and hand it to him. Few weird stains but he likes the tits he says. He hasn't seen tits for a while. He sees an article and goes quiet. I fucking didn't think, did I. didn't think that would be in it. 'How's the job

hunt gong,' he asks. Thought I would have got a job by now to be honest. Thought there would have been loads to do here with the Olympics going on but there's not. Don't want to show their foreign guests scummers like me do they. Great mate. Thanks for asking. He says he's not arsed about tomorrow, says it was bound to happen sometime. But I know he's terrified. I haven't seen him this terrified since school and Jonny Grogan said he was going to twat him for fingering his sister in the toilets of Superbowl.

KIRSTY: Haven't been out for a while. Didn't want to. Didn't want to be the one ruining their fun. But because I wasn't going out for a bit, do you know what they called me? Frigid. It doesn't even make sense. So, this is my first night for a while. What do you think of this? Gemma's wearing a lycra jumpsuit. She's so small, she'll look like a fucking child at some gymnastic competition. All those paedos that stand at the side of the dance floor go mad for her. So everyone else tries to be just like her. Everyone else tries to be little skinny Gemma in jumpsuits. Works when you're skinny babe! If you're not you'll just look like a sausage.

JOE: Pussy is getting better mate. You'd think all the good ones have just gone to uni but they just keep fucking coming. Like a never-ending conveyor belt of perfect pussy. Specially in summer. Don't think about the sad stuff. I used to love that in summer. Walk home from school, do your homework, get out and play footy. I tried hard at school but the teachers wouldn't give a fuck, I was shit so they just left me to fail. Said I could only get a C and I tried, I really did. But I just wasn't clever enough and when I fucked up my SATS I just took up wanking instead of homework… And if you can't get any there's YouJizz innit. You see that Rupert Murdoch and the dwarves one? Was sick. This'll ruin it for you. Find a freckle on your hand. Look at it. Think about your mum. Now every time you whack one off and see that your mum will be in your head. Imagine if you found a video of your sister on there. Legs over her head and some massive german fella pounding on her.

Could you carry on? Nar me neither. Unless you're into that type of thing. Probably don't even stop half the time. Dirty bastards. Got grounded once for getting caught doing that yano. Not watching a video of my sister. Obviously. Just normal. Mum came up with a cup of tea and caught me. Pants down, thingy in hand. Our eyes like meeting in mutual embarrassment. Cheers mum. Yeah I'll see you at dinner.

KIRSTY: Gemma wants to be a model. Err…you can't be a model with a jaw like Cheska from *Made in Chelsea*. Sorry babes. The worst thing is I used to be thinner than her. I don't even eat anything. Well obviously I do. And I tried the Carol Vorderman workout video. I don't get those videos, are they supposed to make you feel like shit? I showed Gemma, 'I could do that,' she goes. Gemma's got ringworm. And she sucked off Gareth Hughes in a toilet during Geography. Miss Davies didn't even notice. It's cause she's thick. I used to think that I was the thick one but now I realise I'm not it's her. She's not even a real teacher she's just a fucking talking lesson plan. Ask her a question and she hasn't got a fucking clue. I don't give a shit about rocks anyway they are boring. I want to be a psychologist. I'm gunna do it at A-level. Since what happened I've decided to do my best to do what I want to do.

JOE: I walk Woggy home to his mum's flat. Carry his bags.

KIRSTY: They said I should consider Nursing.

JOE: He looked so sad.

KIRSTY: Said I might find the prospect of Psychology intimidating.

JOE: See ya tonight cock head I say to try and cheer him up. It doesn't.

KIRSTY: What?

JOE: Took a girl out last week.

KIRSTY: Arseholes thought I was too thick. Fat careers advisor didn't know what to do when I told him I wanted to be a psychologist. Was shocked when I said I wanted to go uni.

JOE: Let's go the theatre she says.

KIRSTY: Gave me the old raised eyebrows and said, 'Do you know it's 9 grand?'

JOE: What am I, gay?

KIRSTY: It's a lot of money but it's worth it.

JOE: If you pay I'll go.

KIRSTY: He had a lazy eye that rolled everywhere that distracted me so to be honest I wasn't really listening.

JOE: If you can convince me that it's better than the cinema I'll go.

KIRSTY: I didn't know where to look.

JOE: The catch is that it's not.

KIRSTY: I mean, do you look at the lazy one or the other? What do you do in that situation?

JOE: If someone explained it to me, art and that, then maybe I'd want to fucking go but I'm spending 30 fucking quid on something that I don't fucking get. I'll just go see Jonny fucking English or something. At least I know what I'm fucking getting with it.

KIRSTY: Tomorrow, I'm going to make a timetable, really big.

JOE: I hope Woggy's ok. I don't know why he wants to go out to be honest. But he does. So fuck it.

KIRSTY: I'm going to plan out everything. Everything I need to do to get into college.

JOE: Tonight's about him.

KIRSTY: I'm even going to smash English just because Miss Gupta said I couldn't. The fat bitch.

JOE: How's this shirt??

KIRSTY: She don't pay no attention to the girls, she just flirts with the boys, makes me feel ill.

JOE: TK Maxx.

KIRSTY: She always bangs on to them about the time she went to see Ed Sheeran.

JOE: Too much like a lumberjack innit.

KIRSTY: English can be so good, but it's cringe the way Miss Gupta took all that hug a hoody shit literally.

JOE: Bit gay?

KIRSTY: She did *Lord of the Flies* as a school play and she had everyone in hoodies and at the back there was a big banner that said 'RIOTS'.

JOE: Too chavvy?

KIRSTY: *Oliver Twist*. Poverty-stricken child dabbles with crime. I get it.

JOE: It's a bit chavvy isn't it.

KIRSTY: *Othello*: BLACK PERSON. KNIFE CRIME. She's so fucking patronizing.

JOE: I said I'd work really hard at school so I could buy nice stuff.

KIRSTY: I wanted to go see the play at the theatre, but school wouldn't take me. Even though I asked Miss Gupta like 4 times.

JOE: And I did try hard just didn't get the grades.

KIRSTY: Only took the top sets.

JOE: So Mum bought this stuff for me.

KIRSTY: Bitch.

JOE: Fred Perry.

KIRSTY: Miss said if Shakespeare were writing for me, he'd make me talk in prose because they're the funniest bits. I pretended I was really offended but it's probably true.

JOE: Calvin Klein special boxers.

KIRSTY: I prefer the poems in English. We did this one 'In Paris With You' by James Fenton the other day. I thought it was going to be one of those romantic poems, but it's not, it's the opposite. It's about fucking around with a stranger, really.

JOE: And we're ready.

KIRSTY: Still, it made me want to go to Paris and speak French. I'm not good at it or anything but I love the sound, and I can speak a bit. I'd love to see the Louvre, Notre Dame, the Eiffel Tower…even the seedy back alleys of Montmartre.

JOE: I have to look sick when I'm out with Jonno and Woggy.

KIRSTY: I said to Gemma we should do that in summer but they want to go Kavos. We're never going Paris, it's all about boys and bikinis with them.

JOE: Can't believe where Woggy's been.

KIRSTY: But until then it's Friday so we have to get smashed.

JOE: But because it's on the news, I can kinda imagine it.

KIRSTY: Getting smashed is what we do.

JOE: Thinking of him in school and now thinking of him like that.

KIRSTY: It happened about two months ago.

JOE: Can't believe what he's had to come back for.

KIRSTY: I don't want to think about it!

JOE: Makes me feel a bit…

KIRSTY: If I think about it then it's real isn't it?

JOE: I can just imagine what he's going through now, sitting in that empty front room. I can see why he wants to go out actually.

KIRSTY: As long as it's out of my mind, then it's OK.

JOE: Last time we were out it was magic. It was one of those days were it's like 3 o'clock and you just know that the whole day lies in front you? You can taste the air. It's palpable. It's real. And the future is like in your hand. I was sitting in the beer garden of that pub next to the train station with Jonno and Woggy, same as every Friday, but this Friday was special. Because tomorrow. Tomorrow Woggy was leaving. Tomorrow Woggy was getting on a train and he might never come back.

KIRSTY: It was Gemma's birthday.

JOE: Parked in the corner was a white van right and some angry-looking fucker sitting in the front seat. He'd just had a proper little scuffle with the landlord, been kicked out and was burning up in his car. Sort of like when you trap a bee inside a glass and watch it twat its own head on the side of the glass. Before I knew what was going on he'd got out and stormed towards us. I pretended my phone rang and walked away he stormed past and back into the pub. Obviously like being a nosy cunt I followed him in to hear what was going on and do you know what he said right? Get this. He goes 'Listen you fat cunt, if you don't serve me now, I'm gonna go out to the car, get a shotgun and shoot you in the face.' Somebody must have overheard right because next thing I know I'm back in the garden and the pigs are all there round this white van. They open it up. And guess what they find? Shotgun, loaded. They took him off in the car and no one saw him again. All the time

there were dirty little kids watching from the wall. Muddy Hands. Weird how I remember that.

KIRSTY: It remember it being hot.

JOE: It's funny to think that like the person we were pissing ourselves at was actually carrying a shotgun like in the back of his car.

KIRSTY: I didn't want to out then either.

JOE: We could have seen Tony the barman get a bullet in his face. What the fuck?! That's like mental. If that had kicked off it could have been us caught in the crossfire and for a second I got this image of my mother walking behind my coffin at my funeral. And she looked so sad. Then I started thinking like, fuck, if I died tomorrow I would have died having done nothing. So I made a promise there and then to Jonno and Woggy that tonight we would live tonight like it was our last, for all we know we might never see Woggy again. 'You're going to have that all the fucking time as of next week Wogster.' And with that I bought a round.

KIRSTY: I just wanted to have a sleepover or something but it's Gemma's Birthday so we have to go out dancing. Yay.

JOE: Foster's. Cold.

KIRSTY: We walked past the park and down the road, and it's odd because the thing I remember most was that time seemed to go really slowly, like you know when it just doesn't matter? Like you don't even think about it because you've got so much. Like when it's still light and it's early on and you know what you're doing that night so you're just like killing time? Yeah. That's what it was like.

JOE: Sambuca.

KIRSTY: Me and Gemma were walking to her's and on the way we go past mine. I don't live in like a big house or anything – just like a little two up two down that I share with me mum, nothing massive – so we both slip upstairs. I

change out of my uniform into some jeans and a t-shirt and get my clothes for the night.

JOE: No crisps.

KIRSTY: Mum's having dinner with that idiot and doesn't even say hello. 'You not eating?' she goes, and I tell her it's Gemmas birthday and I'm going out.

JOE: Wasted calories.

KIRSTY: Mum throws a wobbly. 'I thought we were going to sit down and have a nice meal!' Secretly she's over the moon. I can see it in her eyes.

JOE: Don't want that.

KIRSTY: She loves it, whole house to herself for a whole night.

JOE: We sit down

KIRSTY: So she gives me that 'I understand' look and tells me to text her later.

JOE: and we chat. About tits. On girls.

KIRSTY: When we get to Costcutters, Gemma gives me that 'That's why you're here' look. One of us has to get served and obviously it's going to be me that tries coz Gemma looks like a child.

JOE: I like ones that are hand size. I've only got small hands. Do you reckon that's a B? Nah double B. BB+.

KIRSTY: So Gemma hides round the corner and I'm getting sweaty as I walk inside. The shelves all seem really high and the guy behind the counter looks at me, he's a little Pakistani or Uzbekistani or something astani boy with beady eyes and dirty hair. I freeze. I don't know what the fuck to do after about 5 seconds of freezing and give him a quick awkward smile and slink off behind the shelves.

JOE: Girls get fitter if they have better shoes.

KIRSTY: Fuck I'm nervous.

JOE: We drink Foster's.

KIRSTY: The list on the palm of my hand was blurred. My sweat was like blurring my writing, I shit one and I just grab a six-pack of Carling and a half bottle of Jack Daniel's.

JOE: Becks gives us the farts.

KIRSTY: I walked over the counter all-slow like proper slow and confident like Deborah Meadon on *Dragon's Den* and I put it all on the table. I don't want to look at him. Fuck it I think I've got to be confident or I'll give it away so I look him right in the eye and he's not even looking at the me he's just staring. Just staring right at my tits.

JOE: Really smelly ones.

KIRSTY: 'How much?' I ask him and I like use a little wink to make him think I'm game, so it's more like 'How much?' *(With an over-exaggerated wink.)* Yano? He's just like '£12.55, anything else?' And I'm like, 'No,' and we're away into the evening with a six-pack of Carling and half a bottle of Jack Daniel's!

JOE: It's 4 o'clock now and our special night was getting special. That extra pint and the change in the mood is a little break from the usual Friday. Jonno produces a packet of playing cards and we're playing a game called lowest card necks 3 fingers which is pretty self-explanatory really basically what happens is whoever has the lowest card measures like 3 fingers on their pint and then necks it. Proper quick. Gets you fucked up properly.

KIRSTY: We get to the park and meet everyone else who are sitting on the swings. We take turns doing JD and Carling shots.

JOE: Two beautiful girls drive past in an open-top Mercedes. Dealer's girls no doubt. And they look at us and make a sick face, yano like a *(Sick face.)* … So I toast to them crashing the fucker, arrogant tarts.

KIRSTY: I drink slowly because like then you sort of know how fucked you are and you don't get fucked too quickly.

JOE: So by five right, I am fucking steaming. Like proper steaming. Then Cassie walks in. She looks fucking good. She had the tits. She had the legs. She had fucking everything down to the Kurt whatshisface shoes so I sit there like speechless yano cause I literally haven't seen her for years except on Facebook and here she is standing right in front of me looking fit, with her black hair looking all black and her deep brown eyes looking awesome. And here am I off my tits at 5 o'clock dressed like fucking Bob the Builder. You see the way it works: you spend all your time, sitting in the same pub, on the same day of the week, looking at the same girls and then when you get the one you want they get away. 'Alright darling,' I say real smoothly like.

KIRSTY: I hate seeing my exes when I'm smashed; I always try and get him to finger me.

JOE: She walks straight past me doesn't even say hello. Fucking good. Stupid bitch.

KIRSTY: I always try and make sure I look at least pretty because like you never know who might be there do you? I mean like he might be there with his beautiful new girlfriend. You don't want him to walk past and hear her just like in a little whisper go 'Who's that little rat?' and then hear him go 'No one'. I mean that would just be too much wouldn't it? I mean that would just be horrible.

JOE: I notice her looking over we catch eyes and I give her like a matey smile yano, the type that mates do but because I'm fucked it looks like I'm taking the piss, something like this. *(Face.)* Fuck I'm a cunt. She gives me one of those 'Why the fuck did I ever waste my time with some little gimp like you' faces and like thrusts herself around, yano when people like try to prove a point that they're pissed off about something. *(Shows.)*

KIRSTY: So you have to make sure you're looking good so you can rub it in their face. 'I'm fit, you're a minger and everyone knows it. Alright darling?'

JOE: These is like God telling me by every means possible that I should get unbelievably smashed and have like the best night ever. I'm shit at this game, so I'm necking fingers everywhere.

KIRSTY: It just wasn't going down, you know sometimes when you're drinking and like it's just not happening, it's just sort making you feel a bit ill and you dread every swig you take but you do it anyway because you wanna get pissed but you don't wanna do the whole drinking bit? Yeah it was like that. But I soldier through and I between the four of us the 6-pack of Carling and the half bottle of Jack Daniel's were gone in the hour.

JOE: You can't take it without a light stomach, or at least recently emptied.

KIRSTY: They wanted me to go back to the shop, but I couldn't because they'd know I was buying too much right?

JOE: You get pregnant belly otherwise.

KIRSTY: So someone said 'Gemma doesn't your dad have a whisky cabinet?' Now Gemma's dad was divorced right, and a proper perve, like Jimmy Savile proper. Once we went out, and we came back at like two in the morning we went into the sitting room. The light was off and so was the TV but the DVD player was still was playing and Gemma's dad was sitting there naked in the chair just covering his cock pretending to be asleep. We can all see it's hard.

JOE: *(Toast.)* Jenna Jameson and Ron Jeremy.

KIRSTY: So we all walk to Gemma's. Her house ain't massive so we're making a fuckload of noise. As we get out the

whisky and a couple of shot glasses Gemma's dad walks in. And we all freeze. I'm terrified – I think he's gonna kill us!

JOE: *(Toast.)* The fella behind the bar

'Hello Mr. Fraser,' I say. Big fucking smile on my face like, how's it going? As I'm knecking his bottle of Jameson's.

'It's Jameson's,' *(Pronouncing it properly.)* he goes. 'And there's no way you're drinking that…. Unless I'm drinking it with you.'

JOE: *(Toast.)* My mum's boyfriend Terry. I know it's weird but… I thought I was supposed to hate him but I don't. So that's worth toasting isn't it.

KIRSTY: So there we are at like 5 o'clock or whatever getting lashed with Gemma's dad, we were playing all these games and Sarah teaches us one called 'I've Never' which is like where you say something and if anyone's done it they drink. So we're playing this and all sorts is coming out and someone goes 'I've never kissed a boy' and we all drink obvs like coz were like yano old enough to have done that and obvz like Mr. Fraser doesn't drink and then someone goes 'I've never tried to pull my friend's boyfriend' and no one drinks but I catch Sarah taking a little swing disguising it as a normal drink.

JOE: He was a social worker, looked after old ladies, they all loved him because he was so muscly but he lost his job so he spends all his time around ours now for dinner and that.

KIRSTY: Then someone says 'I have never had a wank over a friend' and I think this is a bit inappropriate like yano, talking about wanking with Mr. Fraser in the room.

JOE: To Terry and his lovely Chicken Ticken Masala.

KIRSTY: In fact like talking about wanking at all isn't very nice and of course no one drinks, and as the chatting carries on I catch Mr. Fraser taking a little swig staring at my tits.

JOE: Wham bam thank you Noel Edmonds I am gone! Like gone enough to think I AM FUCKING AWESOME but not gone enough to be falling over, I don't want to be too smashed so I turn down another pint and opt for a Red Bull and a couple of Pro Pluses like just to keep me buzzing. People looking at me like I'm a prick but I know I'm better that them, that's what keeps me going.

KIRSTY: I mean I don't know if it's wrong but I kind of liked it. I mean boys never pay me attention normally but now it's like I feel really pretty you know, I feel like proper pretty. So I look at him and I pull a little tongue at him. He likes this and just carries on playing. This is fun. You know I'm actually having a good time. I'm actually forgetting about home.

JOE: I know they're thinking 'Still lives with his mum, got no job,' and all that but fuck it, no one's got a job and everyone lives with their mum. They're probably pissed off because they have to do their own washing and make their own breakfasts. Fucking losers.

KIRSTY: He's kind of cute. Obviously I wouldn't because he's Gemma's dad yano but I know what women would see him, got that kind of like George Clooney meets Lenny Henry thing going on. And he smiles a lot I like it when guys smile.

JOE: Some of my mates have got Masters from good universities; Manchester, Bristol, Leeds Met but none of them have jobs they like. At least me and Woggy do something we enjoy.

KIRSTY: Fuck it, he said, he just went 'Fuck it I'm going out tonight.' Gemma's all like 'Not with us you're not,' and he just goes, 'No thanks darling, I'll leave you ladies to do your thing. I'm going with Barry.' Now Barry was this massive fucker, like proper massive yano – arms like pop eye – proper fucking huge. I remember once we were in the pub and he's sitting there like with 3 girls! 3 fucking girls all to himself and he's not even hot. It's just because

he's loaded. I heard he did time cause apparently he's well into dealing. Jonny Grogan buys weed off him and I know he does pills as well so he probably got them off of Barry too. Barry got done for killing a dog. It belonged to this other fella who called Barrie's wife at the time a mongrel. Now his wife was mixed race, and Barry didn't like that so he killed this fella's west highland terrier.

JOE: What have these people actually done? Gone to uni, and got a 9-5. Their souls die at some office while they enter numbers into a computer about paper. Fuck that. Look back in 30 years and say 'Fuck – I was never free!' Education – Education – Work. To be honest that's worse than having your balls cut off.

KIRSTY: I reckon Gemma's dad was thinking about trying to pull me. I don't know why but I got that vibe off him. Gave those eyes that say, 'I want to undress you and I have a massive cock,' you know.

JOE: Jonno does that and he's fucking miserable.

KIRSTY: I dunno why he's looking at me outta all of the girls here, no one ever looks at me first.

JOE: We decide girls peak when they're 14.

KIRSTY: Why am I thinking about Gemma's dad like that?

JOE: All the girls we know who were fit then have gone downhill now.

KIRSTY: That's rotten.

JOE: And all the ones who weren't fit then are now. It's a fucking seesaw.

KIRSTY: He is a real man though.

JOE: I do not want to sleep with a 14 year old. They are fit. But I don't want to touch them.

KIRSTY: We go upstairs to Gemma's bedroom – it's tiny and there's like LOADS of us in there. When we were getting

dressed I kept thinking that Gemma's dad was like outside waiting for me and he was going to whisk me up in his big strong arms and just pin me up against a wall. In reality Gemma's dad was probably in his room tossing off to the idea of all of us having a pillow fight in our underwear. I would never tell Gemma this she wouldn't like it. She'd have one of those little hissy fits she has. Get this right when we were like in year 4 or something this girl bought the same shoes as her and she didn't like her anyway so when we were in church, it was a christingle ceremony, Gemma stood behind her and set fire to her hair and she was wearing like hairspray so it went whoosh. The church stopped because this girl was just crying and screaming. It was amazing but made you think like that this girl is pure evil.

JOE: So this guy walks in right, and he's the cross between a potato and Keith Chegwin.

KIRSTY: Nasty.

JOE: And a bit of a pirate. And he's dressed like like Johnny Depp meets Pete Doherty, which is odd like for round here. Looks like a fucking psycho because mixed with the hair and eyeliner he's wearing a Rocky Balboa hat and driving gloves.

KIRSTY: They used to be looser than this.

JOE: We keep our head down like in case he comes over and sits with us. Fucking insane.

KIRSTY: Arghhhhhhh.

JOE: He looks at us and disappears inside. Before any of us can heave a sigh of relief he's back with a round; one for me, one for Jonno and one for Woggy. For himself he's got a Piña Colada. We don't even fucking know him.

KIRSTY: Fuck it I'm wearing a skirt.

JOE: He's actually quite sound even if he is a bit weird and because I'm smacked off my tits on Red Bull I'm paying him loads of attention like fucking loads of attention.

KIRSTY: Fuck

JOE: He's telling us he used to be a poet but he couldn't write poems. That doesn't make much sense to me now does it?

KIRSTY: That's ok.

JOE: Woggy tells him where he's going and he buys him a shot and that he's got this flat just over the road and we can come round and have a drink if we want. Now I'm a bit nervous like he looks like a fucking psycho. Like fucking, Engelbert Humperdink

KIRSTY: I need a shit.

JOE: But fuck it tonight's the night we promised we were going to make tonight like it was going to be our last so we fucking go round to psycho pirate's house. Later on we find out his name is Jesse. Pretty gay for a pirate.

KIRSTY: Better.

JOE: I don't reckon it's his house because it's got like fuckloads of 60s décor yano all yellow flowers everywhere. On the walls there are loads of pictures of cats. There's fucking doilies everywhere like under lampshades and vases and that. Like some kind of homage to a dead grandmother.

KIRSTY: Not too bad actually.

JOE: Jonno passes out within 20 minutes of being there so we steal his keys so he shits one when he wakes up. Woggy and Jesse the pirate are dancing around the kitchen singing that Butlins theme tune in his face yano 'I've had the time of my life' one.

KIRSTY: Good.

JOE: Whilst they're fucking about I go upstairs. It's not very big like – just a two up two down – and I go into this room

right. It's like, empty, except for a single made bed and a wardrobe, white, like a throwback from the 80s. I can't help but open it and I end up seeing all this stuff.

KIRSTY: I need to shave my legs.

JOE: What the fuck!

KIRSTY: Feels like a dog or something.

JOE: There's loads of pictures of Jesse dressed like Lilly Savage. Kissing all these boys.

KIRSTY: So I go in the bathroom right and I'm looking for Gemma's razor, I'm too afraid to ask because I know she'll say no. Then something catches my eye on the window sill. I grab Gemma's dad's razor and shaving foam and just cover my legs in the shit. I feel naughty but it's nice and as I run his razor over the inside of my thigh I imagine that he's running his cheek across there.

JOE: A Tranny Gay. Are you fucking kidding me?

KIRSTY: I rinse myself off and dry my legs on the hand towel.

JOE: Fuck this right I grab Woggy and lead him out.

KIRSTY: When I come out, everyone looks well pretty now, like seriously pretty.

JOE: We walk out the door and the sun streams onto our faces.

KIRSTY: Oh my god Gemma that dress is beautiful, you look like Kate Middleton or something.

JOE: And we're back in the beer Garden.

KIRSTY: Where did you get it from?

JOE: Fuck! We left Jonno in there.

KIRSTY: How much was it?

JOE: So we go back up to the door to ask for our friend back, and we find it unlocked. We walk into the house and we

see Jonno where we left him, conked out on the sofa, drooling on his Ben Sherman jumper. As we go in to get him we see Jesse sitting behind the door

KIRSTY: So gorgeous.

JOE: with a sketchbook drawing his face.

KIRSTY: Sabrina says she'll go the shop.

JOE: We grab Woggy and drag him out of the house leaving Jesse the pirate sitting there speechless. What the fuck is he doing in his nan's flat dressed like a pirate from a 80s blockbuster, where there's pictures of him kissing fucking boys dressed like a tranny, sketching a lad who's passed out on his nan's couch.

KIRSTY: She comes back with like pure VIN.

JOE: You could have been raped sunshine!!

KIRSTY: I'm saying Vin because it's French.

JOE: He throws it up into one of them bins for dog poo.

KIRSTY: French is sexy.

JOE: Another 3 Red Bulls later and 4 Pro Pluses later Jonno is back in action and we're back on the tinnies. 7 o'clock and afternoon's become evening. We are fucking the fucking testicles.

KIRSTY: I'm up for it now like so for jokes I say TO CHERYL COLE, LONG MAY SHE BE QUEEN OF OUR HEARTS and down a whole glass of Vin.

JOE: To shoes and skirts may they end up on our floors.

KIRSTY: Wish I hadn't done that…

JOE: We are such fucking LADS!

KIRSTY: Actually no it's OK I've lost all that 'Oh I don't really want to go out' now. All I can feel is getting fucked, I don't feel sick and I know I can keep drinking.

JOE: I remember we went on holiday once and Woggy goes up to this bird and goes 'I love licking pussy.'

KIRSTY: Someone texted me.

JOE: Then he picks up an actual cat that was just walking past like and licks it.

KIRSTY: Mum.

JOE: Obviously he didn't get his fingers wet.

KIRSTY: 'I will be safe. Love you xxx'

JOE: What a fucking Lad.

KIRSTY: Gemma gets her phone out and starts talking pictures of us all so we like pout, like this, like we're all Khardashians.

JOE: Where we going tonight boys?!

KIRSTY: Can't wait now.

JOE: Yeahhhhh.

KIRSTY: Do you know what I like? The train ride, there's always some fit lad on the train and because you're all dressed up looking nice like, proper nice you feel well confident and because there's loads of you you feel safe like, nothing's going to happen to you. I'm fucked.

JOE: Me and Jonno are both fucked off the Red Bull/Pro Plus complex.

KIRSTY: We're about to leave and there's a little knock on the door.

JOE: Yeahh!

KIRSTY: Gemma's dad walks in, looking fit. Why do I keep doing that?

JOE: I'm a Trojan a fucking Trojan.

KIRSTY: I've got a surprise for you he says. Come downstairs. So we traipse downstairs, we're all a bit pissed and wearing high heels so it's a bit hard but we get there. This house is really shit, I kind of feel sorry for her, it's like a crack den, there's no wallpaper and all the furniture is just ruined like they've picked it out of a skip, there's that weird smell that smells like there's been nothing cooked but oven baked smileys for years and someone spilt something ages ago but forgot about it and now there's mold growing in the corner, asbestos on the ceiling.

JOE: Macca's at the station. Fat cunt. Used to be a sick at footy until he broke his foot. He pissed in Miss Gupta's cup once and left it on her desk. Shouldn't laugh really. Because of him that she was a prick to the rest of us.

KIRSTY: Gemma's dad opens the front door, and there it is. I would never have thought he was going to do this! I looked at Gemma and she's speechless, she just starts screaming, like arrrggghhhh!

JOE: Funny how there's always one dickhead who ruins everything.

KIRSTY: He'd got us a limo.

JOE: When you watch all those old videos about Heysel or something and you can see them, those 20 or so dickheads that started it all. One dickhead ruins it for everyone.

KIRSTY: I've never seen her this happy.

JOE: All right Melon Head.

KIRSTY: 'Happy Birthday darling' he says.

JOE: Was having a joke mate.

KIRSTY: 'I love you very, very much.'

JOE: He's carrying like a big bag full of robbed trainers.

KIRSTY: Apparently he'd been saving up to get her it.

JOE: They're nice mate.

KIRSTY: It was probably a lot of money for him.

JOE: No I don't wanna buy any.

KIRSTY: I wish my dad was like that.

JOE: Because I've already got some Air Force One's mate.

KIRSTY: Where do you wanna go Gemma?!

JOE: I said I'm sorry.

KIRSTY: We all clamber in. It's a big fucking thing like a fucking hummer or something and she goes 'How long have we got it for?'

JOE: I said no.

KIRSTY: And the driver says we've got it for an hour and we can go anywhere we want, there's champagne in the back so we take it out to the fields. It's gorgeous out there and we spend the next hour just driving round drinking champagne and looking out over the grass that doesn't seem to end and I imagine that years ago there would have been battles and wars here. That's how big it was.

JOE: Jonno buys them for 5 quid if he fucks off.

KIRSTY: Gemma was so happy and I could tell her dad was as well, seeing his daughter so pleased with what he'd got her.

JOE: 9pm and we're on the platform, feeling a bit tired and carrying an extra pair of shoes, but its alrite because we're going out innit, getting fucked up and that.

KIRSTY: This was going to be special. I just wish I wasn't so fucked.

JOE: Obviously Jonno didn't need them so he just threw them off the bridge.

KIRSTY: Where are we going first?!

JOE: It's funny thinking some fucker had just seen a pair of shoes fly out of nowhere.

KIRSTY: McDougal's.

JOE: Probably thought it was a sign from God that they should do more running or something.

KIRSTY: Shit.

JOE: And we get the train and land in town.

KIRSTY: McDougal's is one of those bars that does those things called Body Shots. Basically Body Shots are where they get a girl to lie on the table and they like squirt whipped cream on their tits and they lick it off and they put a banana in their pants and you have to eat it out of them. And you have to do a shot out of their fly as well. It's weird but usually they're quite fit so it's okay. I can see it at the top of Chapel Street. Looking shit.

JOE: Step out onto Chapel Street; it was called Chapel Street because there was a church at the end, now there's a Lloyd's bar, funny huh.

KIRSTY: Who am I kidding, it's sick!

JOE: We're going to The Albert which is basically the arsehole of the strip. On Saturdays they do Karaoke which is fricking banging.

KIRSTY: I've only like done stuff with a few guys and my first one works in there. I don't want to see him.

JOE: I never sing like just watch.

KIRSTY: Even worse watch him give Gemma a Body Shot.

JOE: I'm too good like wouldn't wanna embarrass them.

KIRSTY: He only fingered me once and it was horrible. He told me he knew what he was doing and it just hurt and when he took his fingers out they were covered in blood it was fucking horrible. I feel dirty even thinking about it.

JOE: It's like an old Victorian railway pub, Red Brick, massive, probably was a Hotel once like but now there's not enough business for it to be worth it so it's just like a big building and the landlord lives upstairs. So we go inside and the weirdest thing happens right. I shit you not there was a fella with one arm sing 'I'm just dying in your arms tonight,' that fucking doesn't happen in stories man. Only in real life you'll get that type of shit.

KIRSTY: I really don't want to see him.

JOE: 3 pints mate. And we take them and sit down to watch the freakshow that's about to commence.

KIRSTY: But she's proper set on it and it's her birthday so I guess I have to go in.

JOE: This is quality.

KIRSTY: Fucking Gemma.

JOE: I can't sing but I'm like forced onto the stage in that way that only your dickhead mates can do and I stand there.

KIRSTY: Troll.

JOE: What am I singing?

Hi Ken!

KIRSTY: No you look lovely babe.

JOE: *You wanna go for a ride?*

KIRSTY: Nar you can't even see the ringworm.

JOE: *Come on Barbie let's go party. Come on Barbie let's go party.*

KIRSTY: You wana borrow some foundation?

JOE: Fuck this! I'll do a rap instead. Sup ma homies, this is J to the O to the E to the E Z Ladies. *(Actor ad-libs bad rap.)* Hey who are you calling Dappy you fat cunt? You look like… Fuck off.

KIRSTY: Perfect.

JOE: We've gotta leave.

KIRSTY: Seriously. You can't see the ringworm.

JOE: Just put it down mate we're leaving.

KIRSTY: We go in, and oh my God, he has got FAT!!

JOE: I didn't mean to upset ya. We forget the pints and as bottle whizzes past my head I make a dash for the door, it's getting darker now, the night is upon us. It's coming at us from over the river.

KIRSTY: Hey you I'll have one of those body shot things! I wanna watch him watch me looking fit and licking cream off a man's pecks. I choose the barman who looks like Ashley Cole. Hey you!

JOE: As we get across the car park a volley of glasses smash all around us and we run off down road. Woggy pulls his pants down. What a spotty arse!

KIRSTY: Mm that is a big banana!

JOE: How do you even get a spotty arse?

KIRSTY: I feel like a fucking woman. Look at me you fat cunt, this is what you're missing out on!

JOE: To MacDougals!

KIRSTY: I look over and my ex is cleaning a glass looking at me. Ha!

JOE: We go in and it's like rammed with jailbait. Proper naughty.

KIRSTY: The fit barman says he finishes in an hour. He helps me off the bar, slipping a bit of paper into my hand. Oh god...

JOE: There's a queue of birds waiting to lick cream of a man's nipple.

KIRSTY: Enough battery, good. I'll call him in an hour.

JOE: I've got an idea. I tell Woggy and Jonno I'll meet them in there and I dash over to the shop next door. Little farewell present to Woggy.

KIRSTY: This is going to be such a good night!

JOE: I see it, I grab it, and I take it to the counter and pay my 16p.

KIRSTY: And then people just start coming up to me.

JOE: I go back into MacDougal's proper up for fulfilling the tradition; I go to the bar and with my pelvis tight to the counter tuck it in.

KIRSTY: I must be looking alright.

JOE: Then I jump up on the bar, banana hanging out of my pants and I wave it in some girl's face, yeahhhh.

KIRSTY: Hello.

JOE: Take that you slut.

KIRSTY: What's your name?

JOE: Next thing I know some massive fucker has got me on the floor tugging at my banana

KIRSTY: Nice name, sound like a film star or something.

JOE: and he grabs me by the scruff of me neck and lashes me on me arse outside.

KIRSTY: Double please.

JOE: Why the fuck did I think that was a good idea.

KIRSTY: Woopsy, got to go my friends are calling me, it was so nice to meet you. Byeeeee…

JOE: Where to next boys?!

KIRSTY: Where to next girls?!

JOE: Banter.

KIRSTY: OK I feel a bit sick.

JOE: We walk up to the bouncer at Bar Non and he's looking at us kind of funnily like, probably because we're all FUCKED! Ha!

KIRSTY: Omg that's better I thought I was gonna vom or something.

JOE: We wait in a queue. I get asked for ID and all like 'What you talking about blud am 25,' so I whip out my driving license and show him the picture of me in my pink shirt looking cool as fuck.

KIRSTY: And we walk straight into Bar Non. No queue. Cheers boys.

JOE: Cheers mate, I utter to the Homer Simpson lookalike fat cunt of a bouncer and I bounce in.

KIRSTY: A load of trolls have just walked in.

JOE: 3 Sambucca's and a bottle of beer.

KIRSTY: Eugh. They're doing shots.

JOE: Each.

KIRSTY: Where's Gemma.

JOE: What the fuck.

KIRSTY: I turn around to see the lad in the shit Ben Sherman jumper at the bar as he just rams his head into Gemma's tits and blows a raspberry.

JOE: Get off Jonno you muppet.

KIRSTY: She is not gonna like that.

JOE: I saw him coming from miles away.

KIRSTY: Don't!

JOE: His head like Goliath towering over everyone in there. Not even Woggy could have him.

KIRSTY: Barry, Gemma's dad's mate cracked a glass bottle over the boy with the Ben Sherman jumper's head.

JOE: As the glass first smashed across his face naturally a real man's reaction would be to go for the fella that did it and in my mind I saw myself doing it, I saw myself run over, grab him, wrestle him to the floor. In reality I thought 'Thank fuck that wasn't me,' and screamed like a little girl and ran straight out of the club and hid behind the chicken shop bins.

KIRSTY: Gemma's dad didn't look as nice as before, something had come over him. I felt dirty for thinking about him the way I did. He was covered in this cheap jewelry, like some Gigolo or something, with Barry like a bulldog at his side. I can see him looking at me so I just turn around and walk away.

JOE: I was hiding when I saw the ambulance pull up and coppers run in. This was the worst I'd ever felt in my life.

KIRSTY: I was standing by the door when the paramedics and police run in. This was the worst thing I've ever seen. All the girls were pissing themselves, fucking dicks. I just had to get out of there.

JOE: This girl walked out of the club, she's standing there, the ambulance light flashing on her face and amongst all that shit, amongst all the chips on the floor, and the sick and the smashed glass she looks amazing, like she doesn't belong here.

KIRSTY: The air was so warm I could like taste it.

JOE: Fucking beautiful.

KIRSTY: I decided to walk into the bar opposite called O'Rileys or something. Some of the boys from our year were out and they usually go in there.

JOE: She walked into O'Rileys on her own. Girl in my year got raped there.

KIRSTY: It was full of scummy old people and they all just looked at me like a piece of meat, like dogs drooling over a slab of steak.

JOE: I followed her in and she was looking lost by the bar.

KIRSTY: This boy walked in behind me – I recognized him from the last place.

JOE: *(To KIRSTY.)* What's a girl like you doing in a place like this?

KIRSTY: I didn't want to be alone and he wasn't too bad looking. He seemed nice enough.

JOE: Let's go somewhere else.

I take her down the road to a place called Kooki which was like one of the places with leather seats and nice glasses, paintings and stuff. Dead classy. No banging base lines. Just conversation. Posh.

KIRSTY: It was a bit tacky like but I could tell he liked it so we went in.

JOE: Time to be sober Joe.

KIRSTY: Who are you?

JOE: I've read this book called *The Game*, which is like an instruction manual on how to pick up women and it said to never give a name.

(To KIRSTY.) Doesn't matter.

Keep them on their toes.

KIRSTY: OK.

JOE: She must be about 25 judging by the way she dressed, proper sophisticated.

KIRSTY: This is weird.

JOE: Do you…

KIRSTY: Oh fuck! I'd forgotten about the barman from McDougal's so I tell the boy who won't tell me his name that I have to go out to make a phonecall.

JOE: I don't mind you leaving ladies, because I love to watch you walk away.

KIRSTY: Fuck I'm nervous.

JOE: I don't actually say that.

KIRSTY: The barman picks up straight away. 'Where are ya?' he goes. 'Just down the road.' 'You alone?' 'Yeah.' 'Wait there, I'll pick you up.' I wait outside for the barman to come, and after about ten minutes, this car pulls up with blacked-out windows.

JOE: I feel like a tit.

KIRSTY: As I walk over, the window starts to wind down.

JOE: Do I leave?

KIRSTY: The hot barman is sitting there with a massive grin, but he wasn't alone.

JOE: I'll give it five.

KIRSTY: Before I realise who it is, they lash a cup of liquid in my face.

JOE: Two more.

KIRSTY: It's piss. I look up and wipe my eyes and the barman is sitting there…with my ex in the passenger seat.

JOE: 30 seconds.

KIRSTY: Fucking cunts!

JOE: Does this always happen?

KIRSTY: I go straight back in the bar and I see the stranger waiting for me. I'm not arsed I'm covered in piss. I'll never see him again.

'Get me fucked', I say. 'I'm going the loo.'

JOE: What happened?

KIRSTY: Doesn't matter.

JOE: You smell funny.

KIRSTY: Just get me a drink?

Funnily enough he obliges quite willingly and when I get back he's sitting there with a nice bottle of white wine – 'Echo Falls Du Blanc' he calls it.

JOE: You looked a bit upset so I splashed out.

KIRSTY: Mum would find that really funny.

JOE: We stick around for another glass and she is lovely. Like, genuinely nice.

KIRSTY: He's a bit of a chav but there's something hot about him.

JOE: Nice eyes.

KIRSTY: Big hands.

JOE: What the fuck is she doing with me?

KIRSTY: I've run out of money.

JOE: Do you wana go home or something?

KIRSTY: Dunno.

KIRSTY: *(To audience.)* I know what'll happen when I get home, Mum will be banging that fat fuck she met on Facebook on the couch. I wish I could stay at Dad's.

JOE: Want to share a taxi? I'll pay.

KIRSTY: He won't get a Black Cab – says it'll cost too much – and rings one of those like local taxi cars. When it comes, the driver has this massive moustache and stinks of coffee and cigarettes. Like, if I told you to shut your eyes and imagine a taxi driver who would smack your arse as you leave the car, then this would be him.

JOE: Hi Jack.

KIRSTY: He fucking knows him.

JOE: Good night?

KIRSTY: Ew.

JOE: 14 College Avenue please.

KIRSTY: As the car drove along, I kept thinking about Gemma's dad. About 4 hours ago I thought I could get any man I wanted, and somehow I ended up going back with fucking Del Boy.

JOE: How much?

KIRSTY: Weirdo.

JOE: This is going well, when there are 3 people in the car and you know you're going home with one of them; always talk to the third one. Saves up the conversations for later.

KIRSTY: Why's he ignoring me?

JOE: I'm awesome.

KIRSTY: Where are we?

JOE: Nearly there.

KIRSTY: I don't recognize any of these places.

JOE: It's the country road

KIRSTY: Why are we going down a country road?

JOE: Shortcut. Gets us there quicker.

KIRSTY: Oh my God. You're going to rape me, aren't you?

JOE: What?

KIRSTY: Let me out.

JOE: No!

KIRSTY: Let me out.

JOE: What the fuck are you doing?

KIRSTY: Let me out now

JOE: Shut up.

KIRSTY: I said, let me out, or I will fucking cut your bollocks off and use them for earrings I swear to fucking god.

JOE: Look please trust me, we'll stop in a minute, it's just around the corner – look – there's a post office.

KIRSTY: And there it was. The post office. Right next to the estate.

JOE: Why would anyone buy these?

KIRSTY: Boarded-up houses.

JOE: They must have no choice, living somewhere like that.

KIRSTY: Scummy as fuck.

JOE: Someone was proud of that once.

KIRSTY: Looks horrible.

JOE: Some woman cleaning the steps, husband mowing the lawn.

KIRSTY: Just full of scummers.

JOE: Past the graveyard.

KIRSTY: Can't wait to get out of here.

JOE: What did they all do?

KIRSTY: Sick of it.

JOE: They must have done something to be proud of with their lives, had some respectable trade or something. If you've got anything less than a MA nowadays, you're going to work in Tesco's.

KIRSTY: What's he thinking about?

JOE: Makes me sad to say that one day my grave will be there 'Here lies Joe Johnson spent his whole life on the dole – liked a chicken kebab.'

KIRSTY: You religious or something?

JOE: Here we are.

KIRSTY: I didn't mean to scream.

JOE: It's fine, don't worry about it. We step out onto the pavement, dyed orange in the lamp light. Want me to walk you home? Streets are a bit rough around here….

KIRSTY: What? I thought we were going back to your's.

JOE: Oh…

KIRSTY: If can't go back now – I'll get questioned.

JOE: About what?

KIRSTY: Why have I come back alone, have I fallen out with friends, am I feeling well, is something the matter, I'll have to talk to her stupid friend. All they want to do is stay up shagging. They'll just resent me being back so early.

JOE: Well come back to mine for a bit if you like.

KIRSTY: Alright. So we walk to his house, which is a bit weird because I thought the taxi was going to drop us off outside. As we walk there's a weird kind of silence – we go past the estate and the little row of shops and the kebab shop and we come to a house I'd never seen before. It was really nice…like at least 4 bedrooms, had like a 4x4 in the drive and everything, was proper nice but it didn't belong here,

it looked like it should be Miami or something – not this shit little town.

JOE: Chateau Du Joe.

KIRSTY: It's huge.

JOE: Mum chose the palm trees.

KIRSTY: You live with your mum?

JOE: Fuck, shouldn't have said that. Erm yeah, she's not in though. She's the only woman in my life. Don't you think that only women make things nice? She decorated it all.

KIRSTY: I go inside and it is nice...all marble floors with rugs. There's fresh flowers everywhere, big leather seats with a massive TV.

JOE: Sorry it's a bit of a state.

KIRSTY: It's...fine.

JOE: Want a drink?

KIRSTY: What have ya got?

JOE: What do you want?

KIRSTY: Wine?

I sit down on the couch and it is proper nice, I can feel the leather stick to the bottom of my legs.

Oh my God, this is so posh.

JOE: *(Aside.)* This isn't really my house.

KIRSTY: Your house is gorgeous.

JOE: Thanks.

KIRSTY: How do you afford this?

JOE: Dad's in property.

KIRSTY: Are you like proper minted then yeah?

JOE: Yep.

KIRSTY: Thanks for this.

JOE: *(Aside: she believes me, fantastic.)* It's fine, anything for a damsel in distress.

(To KIRSTY.) I like your shoes.

KIRSTY: Thanks.

JOE: They new?

KIRSTY: Yeah. Come here.

JOE: We sit for while just feeling this thing, just feeling this mutual thing between us that I can't even put into words.

KIRSTY: It's so awkward.

JOE: We kiss and it's fucking amazing – she's got like the body of a 14 year old but the lips of a tiger.

KIRSTY: He stinks.

JOE: I think I can smell piss.

KIRSTY: I bite his ear… I read that this is what you're supposed to do.

JOE: What the fuck is she doing?

KIRSTY: Straddle him on the couch, leather sticking to my knees.

JOE: She loves it.

KIRSTY: What are you meant to do now?

JOE: I slide her knickers off onto the floor.

KIRSTY: Oh god! Fuck it. I'll never see him again.

JOE: I can't get it in

KIRSTY: Fuck this hurts

JOE: I literally can't get it in

KIRSTY: I hope he doesn't think I'm a virgin

JOE: This is shit

KIRSTY: ow

JOE: do I fake it?

KIRSTY: urh!

JOE: how would I even do that?

KIRSTY: urgh

JOE: Flip her over

KIRSTY: urgh

JOE: *American Psycho*

KIRSTY: urgh

JOE: I'm the man

KIRSTY: urgh

JOE: Man

KIRSTY: urgh!

JOE: I'm the fucking man

KIRSTY: Argh

JOE: WHAT THE FUCK AM I DOING

KIRSTY: He came in me.

JOE: That was 2 months ago. She didn't take my number she made no effort to get in touch with me, she just left.

KIRSTY: I didn't want to see him again, it was horrible. I just wanted him to be a stranger.

JOE: Just a bird wasn't she, another little slut.

KIRSTY: I left straight away and walked the fucking trek home, through the fields, down the roads and by the time I get back it's morning. It hurt so much.

JOE: quality story that, think about it, I take Jonno's keys to his dad's house, knowing he'll be in the hospital and let me self in telling some little tart that it's mine, bang her on the couch and fuck off. Story of my life probably. Best thing I've ever done. Fuck. That is actually the best thing I've ever done.

KIRSTY: All I could think about the whole way home was getting in the shower. I just knew. I just fucking knew. I tried to ignore it. And before I know it, it's 2 months later and I've done nothing. I saw myself at a crossroads, my life veering off in two separate ways. I look down one it's hard work. But it's my dream. Escaping this. Getting out of all this shit. And down the other, I see myself in school, everyone looking at me but no one saying anything. I imagine Miss Gupta taking me in her office and giving me a copy of *Juno* or something. Then I see a baby bouncing on my lap on some Friday night. I'm stuck in this house, everyone living their lives. No money. Nothing. I could see myself, holding it in my arms. I imagine these tiny hands, and massive, perfect eyes. It's depending on me. It fucking needs me. And I don't want that. So I go to the doctors. I didn't even tell my mum. 2 sets of tablets. 1 day. And it was gone. My womb emptied. I know I won't regret it. It was the only thing I could do.

JOE: I walk home and when I get in Mum gives me all this shit. I'm like 'Please just go to sleep Mum, I've just shat more ale than you've drank in the last 20 years so can you just fuck off.' I whack a cheeky one off before I go to sleep. And in the morning I go the shops to get a massive bottle of Coke and ready salted crisps. Some kids asked me to get served. Fuck it. I go into the shop, ask the Pakistan… Uzbekistani, what ever he is for a half bottle of vodka and I give it them. May as well give them something to make the moment worth living eh. They look fucking bored. I know

58

what it's like to be bored. I'm bored. I want a job that's not boring. All the jobs here are so shit they're just fucking serving people. Wearing shit hats. I know people need to do these jobs and if they stopped the whole world would. I know that, I'm not dissing it. But no one gives a fuck about them. They're battery hens. Fuck that. I deserve better than that. I want to DO something. I want a job so I can sit down in a club and buy a girl a drink and not give a fuck. There you are darling. Have one on me.

KIRSTY: I'm going to try and make the most of my life from now on.

JOE: I had to borrow 20 quid off me mum to go out tonight.

KIRSTY: I'm going to work my fucking arse off.

JOE: I know it's my fault. I know that if I tried I could work, get fit, get a girlfriend, get a job, take up footy again and my life would change completely. But that's all a bit scary isn't it.

KIRSTY: It's just me sitting down and putting my mind to it really.

JOE: Would have liked to have called her really.

KIRSTY: I saw him last week. He just walked past. Didn't recognize me.

JOE: She was fit. And she was lovely. Not many girls like that.

KIRSTY: Fucking prick. If he knew… If he knew what had happened.

JOE: Woggy wasn't interested.

KIRSTY: If I had the balls to speak to him I'd go up to him and say thanks.

JOE: He's got real stories. None of these small-town stories. Solider stories.

KIRSTY: Sounds stupid that doesn't it.

JOE: He's been to fucking War.

KIRSTY: I told Gemma. Her cousin says he knows him.

JOE: And tomorrow he's burying his mum.

KIRSTY: That wasn't his house.

JOE: Puts it all in perspective for me.

KIRSTY: He's done nothing and the worst thing was I believed him.

JOE: I'm not going to do anything with my life am I.

KIRSTY: I couldn't believe he didn't recognize me.

JOE: Might as well get fucked.

KIRSTY: Just another fuck aren't I.

JOE: Fuck tomorrow, it's about today. We're all just fucking Sims characters aren't we. Some of us get clicked on and made the prime minister, others just get locked in a room they can't get out of and are forced to piss themselves over and over again. Some of us are just fucked. That's just the way it is. I'm just a Sim. We all are.

KIRSTY: I want to go to uni. Don't care if it goes up to £20,000 a year I'll pay it if it means not being like him.

JOE: Pre-lash shots.

KIRSTY: I don't give a fuck if I fail. In this town it's not okay to try.

JOE: Here's one to that girl.

KIRSTY: So I'm going to try.

JOE: One more for woggy. Brave man.

KIRSTY: Learn about those fucking rocks

JOE: Woggy's mum.

KIRSTY: and Kenya.

JOE: Last one, when this is down the world will stop being so shit.

KIRSTY: and how the world spins on its axis. I'm going to learn it all.

JOE: The world is the ride of life, and I'm on the front row with a big fucking bag of popcorn. Laughing away with my mates and smiling. We can't change the tracks we just have to sit and go. Enjoy the view and laugh on the way.

KIRSTY: Every day the world is turning, people are born, people are dying, it's turning and it's turning faster and it's leaving all the fuckers like that behind. They're falling behind and dropping off the face of the earth and no one gives a fuck. I don't want to help them. I'm going to make sure that every moment of my life, will be lived.

JOE: But for now it's time to go out.

KIRSTY: But for now it's time to go out.

JOE: At least we've got this to look forward to.

KIRSTY: At least we've got this to look forward to.

JOE: From the cradle to the casket, Friday night will always be good.

KIRSTY: All this.

JOE: That's what it's there for. And this one will be good. This one will be really fucking good.

KIRSTY: Right now there's nothing else to do is there. Nothing else. This is what we're supposed to do. This is being young. Isn't it.

End.

OTHER LUKE BARNES TITLES

BOTTLENECK
9781849434379

EISTEDDFOD
9781849433860

WWW.OBERONBOOKS.COM

Follow us on www.twitter.com/@oberonbooks
& www.facebook.com/oberonbook

Printed by Printforce, United Kingdom